Dear Mama,

you

"big" ♡ W9-DJM-164

Happy birthday with
much love!!

Ricky, Liam + ?

8/19/02

THOMAS KINKADE

Life's Little Blessings

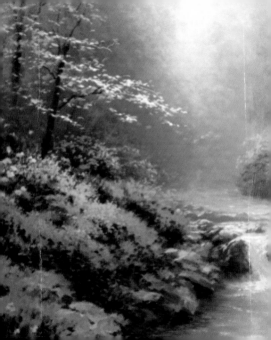

THOMAS KINKADE

Life's Little Blessings

**Andrews McMeel
Publishing**

Kansas City

For information, write Andrews McMeel Publishing, an
Andrews McMeel Universal company,
4520 Main Street, Kansas City, Missouri 64111.

ISBN: 0-7407-2134-8
Library of Congress Catalog Card Number: 2001092774

Compiled by Patrick Regan

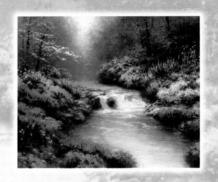

How easy it is to get wrapped up in the hectic pace of our modern lives. We are so often rushing from one thing on our "list" to the next that we rarely take the time to recognize and enjoy those things that matter most.

Blessings surround us if we but open our eyes to them . . . they are present everywhere in those that we love and in this beautiful world in which we live. These blessings, like nothing else we can gain, are capable of bringing light to our lives. In my art, light has a profoundly evocative power—

a power that is both calming and energizing.
And I have learned that a recognition of and an
appreciation for life's little blessings can hold the
same power.

I believe that reveling in simple joys is the greatest
remedy for a complex and frenetic life. They are
never hard to find—these little blessings and simple
joys;—to the contrary, they are impossible to miss
if we slow our pace, find our life's true center, and
take notice of the miracles occurring around us
every day.

Once you begin looking,

you may be surprised to discover

just how much joy

your world has to offer.

—Thomas Kinkade

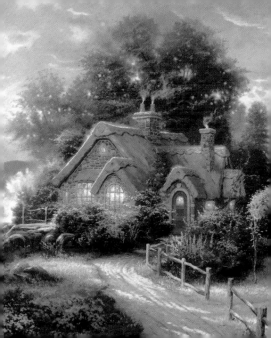

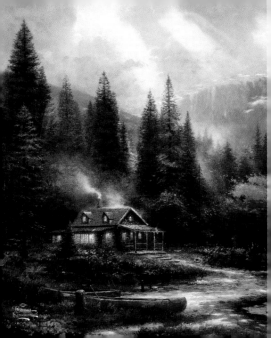

Watch for surprises . . .

a tree full of butterflies . . .

a fresh breeze on a hot day . . .

a simple sense that all is well.

–Thomas Kinkade

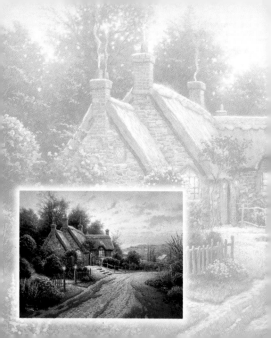

The soul feeds
on simple joys
and withers
without them.

— Victoria Moran

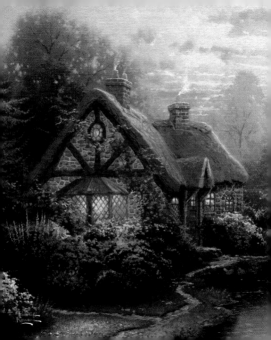

Read outdoors.

Walk in the park.

Park your car on a hilltop

and *enjoy* the view.

– Thomas Kinkade

*Chat with an old friend
over coffee.
Light a candle and
listen to fine music.*

— Thomas Kinkade

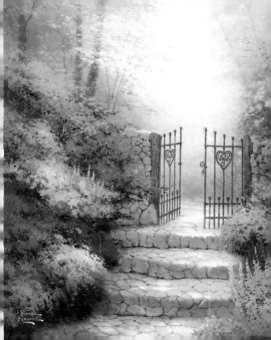

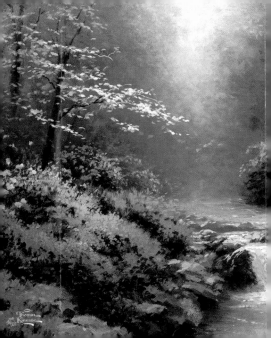

\mathcal{T}he wisest keeps something

of the vision of a child.

Though he may understand

a thousand things

that a child

could not understand,

he is always a beginner,

close to the original meaning

of life.

—John Macy

*Catching the vision
for simplicity
is the vital prerequisite
for exiting the fast lane
and changing life for the better.*

— Thomas Kinkade

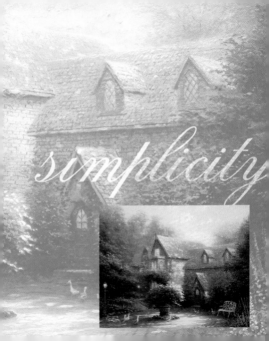

simplicity

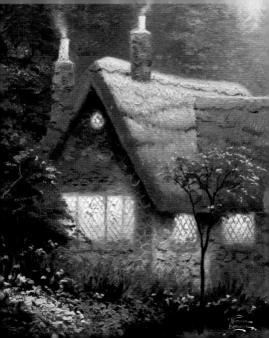

Here is a **simple** *revelation*
that is *bringing me a lot of freedom:*

There is **enough** *time . . .*

—Claire Cloninger

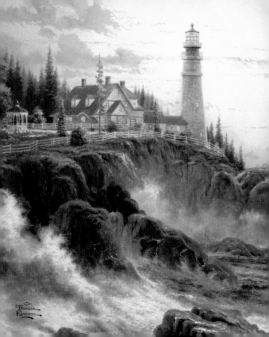

We struggle

with the complexities

and avoid the simplicities.

—Norman Vincent Peale

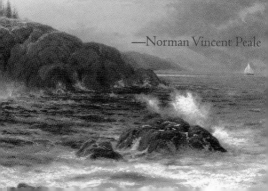

With an eye made quiet

by the power of harmony,

and deep power of joy,

we see into the light of things.

— William Wordsworth

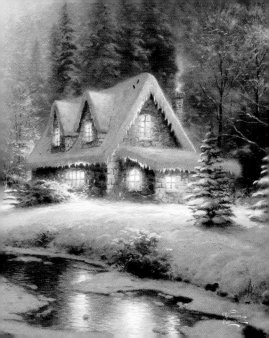

Natural light and fresh air

have the power to restore us

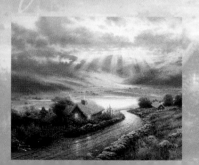

to who we are,

to a sense of completeness.

—Thomas Kinkade

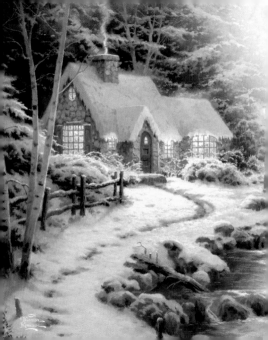

If instead of a gem, or even a flower,

we should cast the gift

of a loving thought

into the heart of a friend,

that would be giving as the angels give.

— George Macdonald

Nature is full of genius,

full of the divinity;

so that not a snowflake

escapes its fashioning hand.

—Henry David Thoreau

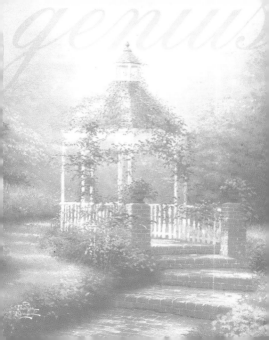

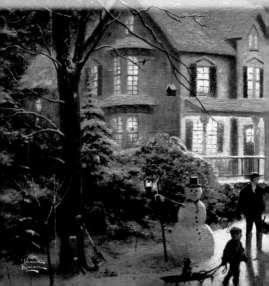

Don't believe in miracles —

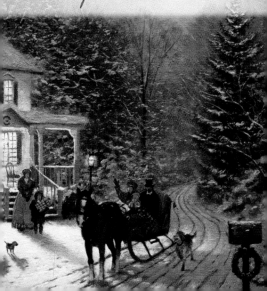

depend on them. — Laurence J. Peter

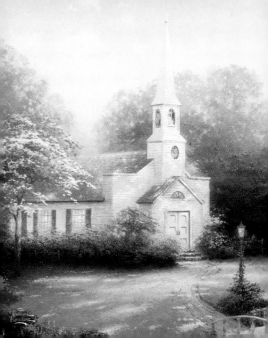

*Our lives
are a precious gift
presented to us
at birth.*

—Thomas Kinkade

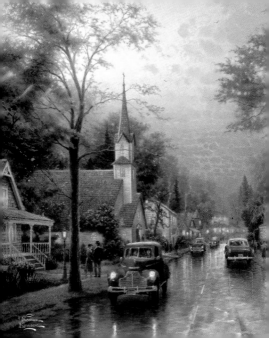

Were there no God,

we would be

in this *glorious* world

with *grateful* hearts

and no one to *thank.*

— Christina Rossetti

Be thankful

that you have a place on this earth—

a physical spot to call your home,

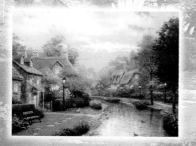

a history that tells your story,

a nest of relationships

that make you who you are.

—Thomas Kinkade

Let us be grateful

to people

who make us happy;

they are the charming gardeners

who make our souls blossom.

— Marcel Proust

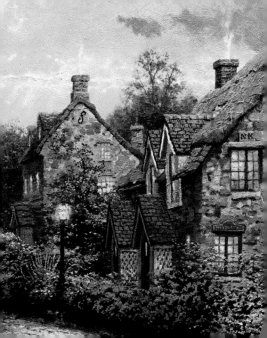

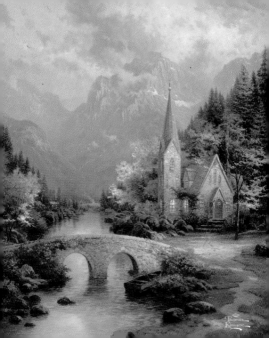

My life shines

with God's radiant

blessings

when my heart

is the color of joy.

—Thomas Kinkade

The flow of blessings
 in our life
 is directly related
 to our passing blessings
 along to someone else.

— Thomas Kinkade

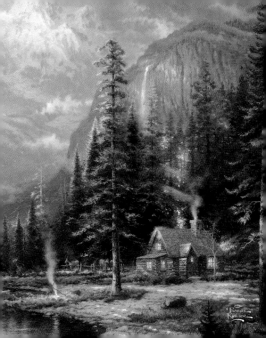

*F*or the truly faithful,

no miracle is necessary.

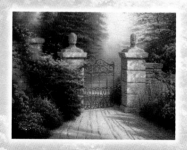

For those who doubt,

no miracle is sufficient.

– Nancy Gibbs

Faith

When I see my life

as a *series* of unfolding miracles,

I'll always *sail* forth with *hope*,

tranquility, and *joy* in my heart.

—Thomas Kinkade

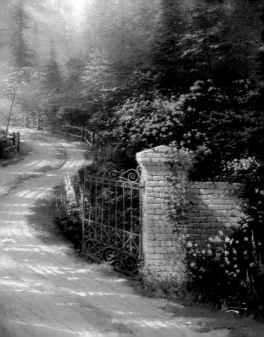

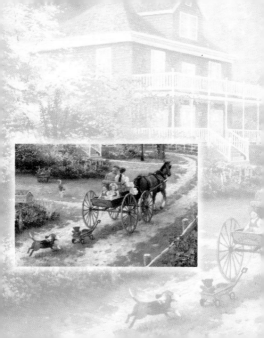

We can see

a thousand miracles

around us every day.

What is more supernatural

than an egg yolk

turning into a chicken?

— Rutherford Platt

Blessed is the influence

of one true, loving human soul

on another.

— George Eliot

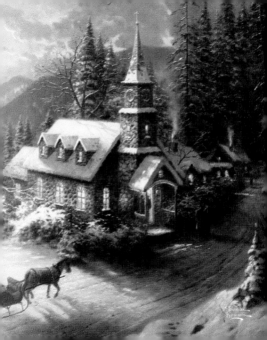

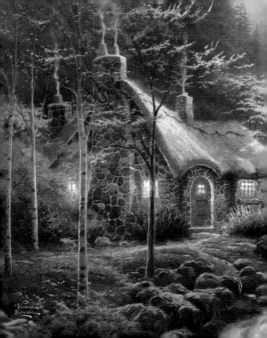

That man

is the richest

whose pleasures

are the cheapest.

— Henry David Thoreau

Each life has the ability

to *touch* other lives,

which in turn touch yet more *lives*.

And so, *person* by person,

generation by *generation*,

a world and a *future* are shaped.

—Thomas Kinkade

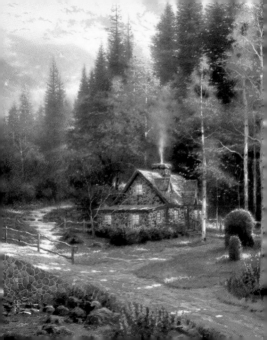

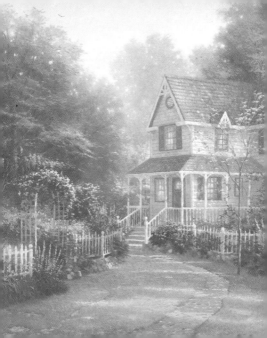

Out of intense complexities
intense simplicities emerge.

– Winston Churchill

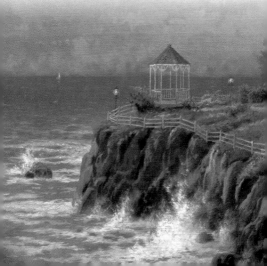

When the solution is simple,

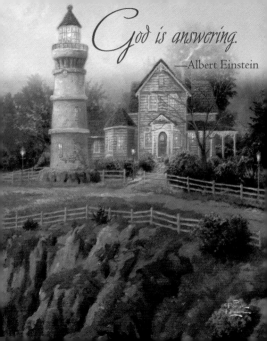

God is answering.

—Albert Einstein

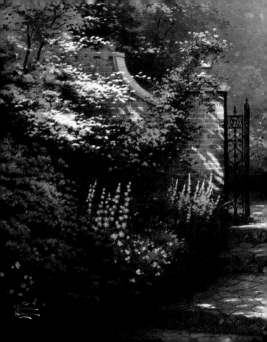

*The trouble with so many of us
is that we underestimate
the power of simplicity.
We have a tendency it seems
to overcomplicate our lives and forget
what's important and what's not.
And as the pace of life continues
to race along in the outside world,
we forget that we have the power
to control our lives
regardless of what's going on outside.*

—Robert Stuberg

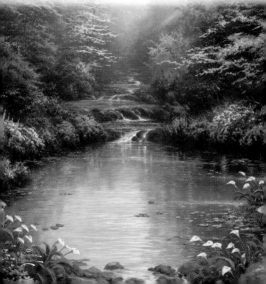

Out of difficulties grow miracles.

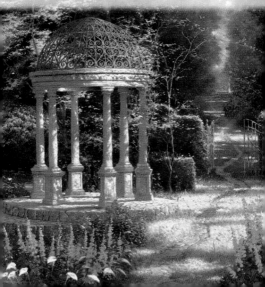

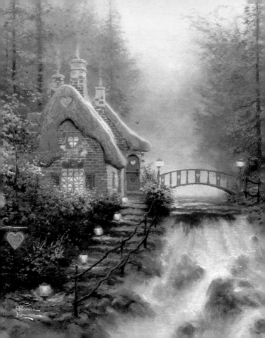

Seeing, hearing, feeling,

are miracles,

and each part

and tag of me

is a miracle.

—Walt Whitman

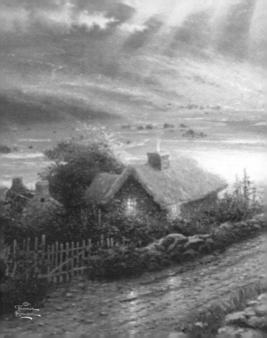

Heaven

is under our feet

as well as over our heads.

—Henry David Thoreau

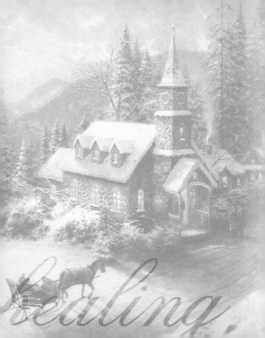

The miracles of the church
seem to me to rest
not so much upon faces
or voices or healing power
coming suddenly near to us
from afar off,
but upon our perceptions
being made finer,
so that for a moment
our eyes can see
and our ears can hear
what is there about us always.

—Willa Cather

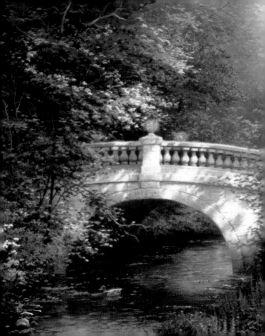

*Our life
is frittered away
by detail....*

*Simplify,
simplify.*

—Henry David Thoreau

Setting yourself up

for joy

is an investment,

not an indulgence.

—Thomas Kinkade

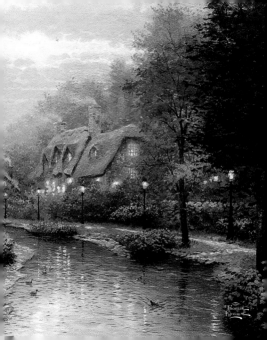

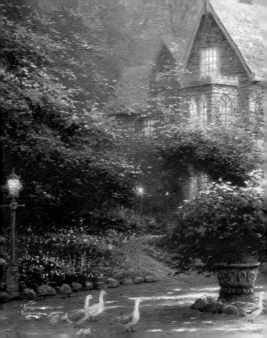

*D*on't forget
to seek out
the daily perks
and joyful surprises
that your life
has to offer.

—Thomas Kinkade

The strongest

and sweetest songs

yet remain

to be sung.

—Walt Whitman